The Complete Art of
BREAKING

by Richard Byrne

Editor: Michael Lee
Graphic Design: Karen Massad
Art Production: Deidre Cosman

© 1984 Ohara Publications, Inc.
All rights reserved
Printed in the United States of America
Library of Congress Catalog Card Number: 84-060159
ISBN: 0-89750-099-7

Tenth printing 2003

WARNING

This book is presented only as a means of preserving a unique aspect of the heritage of the martial arts. Neither Ohara Publications nor the author makes any representation, warranty or guarantee that the techniques described or illustrated in this book will be safe or effective in any self-defense situation or otherwise. You may be injured if you apply or train in the techniques of self-defense illustrated in this book, and neither Ohara Publications nor the author is responsible for any such injury that may result. It is essential that you consult a physician regarding whether or not to attempt any technique described in this book. Specific self-defense responses illustrated in this book may not be justified in any particular situation in view of all of the circumstances or under the applicable federal, state or local law. Neither Ohara Publications nor the author makes any representation or warranty regarding the legality or appropriateness of any technique mentioned in this book.

OHARA PUBLICATIONS, INCORPORATED
SANTA CLARITA, CALIFORNIA

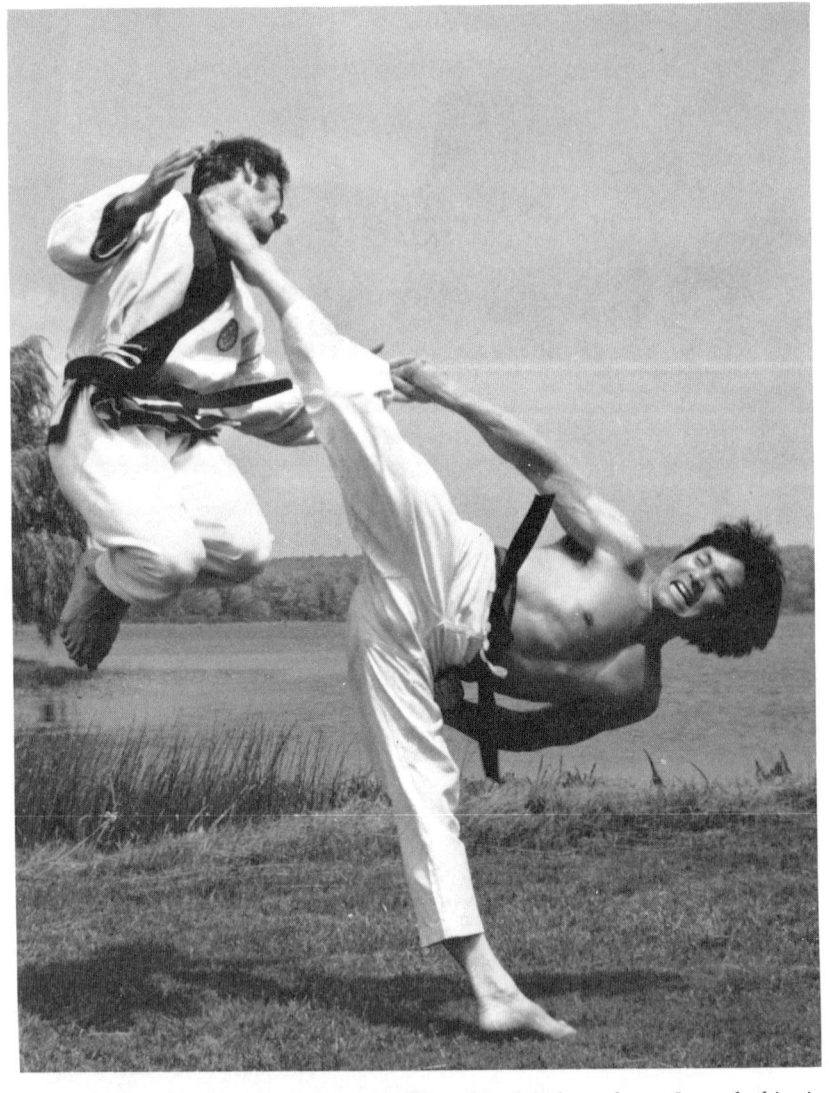

Richard Byrne is one of my outstanding black belt students. I taught him in Osan, Korea. I consider him an expert in the art of breaking. I recommend this book to any student who wants to learn the art of breaking. Through this book, you can learn good technique and how to break boards and other materials safely.

Chun Sik Kim,
President and Founder of
International Tang Soo Do Federation

ABOUT THE AUTHOR

Richard Byrne started his martial arts training in *tang soo do* at Osan Air Force Base in Korea in 1969 while stationed in the military. Byrne, an expert in tang soo do, also holds black belts in shotokan and tae kwon do. He opened his first school in Medford, Massachusetts, in 1970, and since its founding, Byrne's Tang Soo Do Studios have grown to include over 15 schools throughout New England, instructing over 700 students. Byrne is executive director of the American Tang Soo Do Association, and Regional Director of the International Tang Soo Do Association.

He has now retired from competition in New England, and leaves an impressive tournamet record in sparring, forms and most successfully in breaking. He currently holds three world records in board breaking. His best-known record is ten boards with a single chop, followed by eight boards with an instep round kick. Known for his speed as well as for his power, he holds the world's record for breaking 58 boards, one at a time, in only 24 seconds. He is famous throughout New England for his martial arts show entitled "The Total Mind and Body Experience," in which he not only demonstrates his incredible breaking ability, but also entertains many crowds with his mind and body unification techniques.

Many of Byrne's students have become tournament champions in their own right, which illustrates Byrne's expertise as an instructor as well as a performing martial artist.

Byrne has appeared in several action movies. He's also appeared in every major martial arts magazine in the country, as well as on local and national television.

PREFACE
The Science of Breaking

A student who follows the guidelines for breaking, such as correct conditioning, starting slowly and building up, not exceeding individual limitations, etc., need not know the various laws of physics that also govern each break; however, his understanding may be greater if he has a basic grasp of these scientific facts.

Three essentials must be present in order for the break to occur:

1. The weakest point of the object to be broken must be hit.
2. The strike must be initiated from sufficient distance in order to gain enough speed to penentrate the object.
3. The proper part of the body must be used to avoid injury and to pinpoint the exact power/focus area.

In order to understand the break, essentials one through three must be carefully considered and applied.

The laws of physics also govern the way in which an object breaks. Breaking depends upon the manner in which the objects to be broken are set up. One of these laws states that energy (momentum) can be transmitted through an object.

In a set-up without spacers between boards, the bottom board will break first, and the top last. The striking distance, in this case need not be as long as the striking distance required to complete a break of the same number of boards which are separated by spacers. In the latter set-up, the striking hand or foot must make contact with each board and penetrate the bottom board for the break to be completed.

Suspended breaks are also affected by certain laws of physics. Since a suspended board is held only by one end, thus providing resistance only at this point, it must be struck with enough speed to break before it's knocked from the hands of the holder. When the board is hit, it begins to move in the

same direction as the part of the body which is striking it. Therefore, the striking hand or foot must be moving at an even greater rate of speed than the board.

While an individual's size may psychologically affect the breaks he or she chooses to attempt, size or lack of it, *in itself,* is not a deterent to tremendous success in all areas of breaking.

Granted, if a person with greater body mass executes the same punch as a person much smaller, and if both punches are performed at identical speed, the larger person will obviously do greater damage. But, if the smaller person were to double the speed of his strike, he would actually quadruple his striking power.

Since the greater the mass, the slower the movement, it is not difficult to imagine the smaller person's ability to increase his speed and thus his power. On the other hand, if the bigger person can increase his speed by a considerable amount, this increase, coupled with greater body mass, can accomplish some astounding breaks.

The following definitions by Joseph Perez, B.S. and M.A., will give a more technical explanation of physics as it applies in breaking.

Velocity: The time rate of linear motion in a given direction. It is important to generate maximum velocity when punching or kicking, since increased velocity will result in greatly increased kinetic energy.

Joules: A unit of energy. For example, it takes about 6.4 joules of energy to break a one-inch thick board (12x8 "). It takes 8.2 joules to break a patio slab.

Kinetic Energy: Kinetic energy is the type of energy associated with motion. It is expressed as a formula,

$$K.E. = \tfrac{1}{2}m \times v^2$$

in which "mv" represents mass velocity. Note that mass and velocity are components of energy, and that as mass is doubled, kinetic energy is doubled. If *velocity* is doubled the total kinetic energy will be four times as great.

Work: Work equals force times distance. If the total kinetic energy transferred to the board (as a strike), is not high enough, not enough work will be done to yield a break.

Inertia: Inertia is an object's natural resistance to a change in motion. The more massive an object, the more inertia it has. When a punch is directed against a suspended object, only the inertia of the object provides resistance against the moving hand. This is why suspended boards or bricks are thought of as speed breaking, in which the velocity of the strike is so high it breaks the suspended object before it can move with the strike.

INTRODUCTION

This book was written so that both novice and advanced students can develop a better understanding of breaking. Breaking is only one facet of a martial artist's training. It helps develop accuracy, concentration, confidence, speed, and power. Many times a student will ask himself: can I really hurt someone with this punch or kick? Breaking can help answer that question. The more boards you can break, the more destructive power you've developed. Since we advocate using our martial arts ability only in a self-defense situation, our goal is to develop confidence, so that we can successfully apply our classroom training in a real-life situation. Again, we resort to breaking as a means of gauging our actual destructive power, without causing unnecessary physical injury to fellow practitioners. Further, increased confidence can actually enable us to avoid unpleasant confrontations.

Another intention of this book is to destroy the myth that only masters are capable of such feats. Students as young as four years and as mature as 72 years are successfully breaking without injury. Breaking without injury is, of course, a most important point. Anyone can break a board. The ideal condition is to be able to perform multiple or consecutive breaks consistently without injury, since injury defeats the purpose of this training. Apply this concept practically. If, when one is attacked on the street, and he reacts by striking his assailant with an improperly executed hand technique, he has put himself in greater danger, since he has disabled himself by injuring his hand. This is a fairly common occurrence. By studying breaking and practicing its

training methods, your accuracy and ability to strike any given point with the proper hand or foot position will be greatly increased along with the ability to avoid unnecessary injury. Many martial artists spar with protective equipment in order to get the feel of actual contact. This can lessen the necessity to strike with the proper hand and foot positions, thus giving the fighter a false sense of confidence and protection. On the street, one inaccurate or poorly thrown technique could result in more damage to the martial artist than to his opponent. Breaking can develop this desirable precision and accuracy.

While this book offers practical guidelines to successful breaking, nothing can replace good instruction. These techniques should only be attempted under strict supervision. In your eagerness to begin breaking, do not neglect the training methods necessary to toughen and strengthen your body. Caution and common sense should be used. It is not advisable for very young martial artists to perform some of the more strenuous or dangerous conditioning exercises and breaks, since their physical development is the main concern.

I have been performing since 1969, and have never broken a bone in my hands or feet. This should dispel the myth that it is necessary to break parts of your body in order to toughen them. If you have broken a bone or received injury while attempting a break, then it was a result of either incorrect technique or exceeding your body's limitations. Train at a moderate pace and you'll find that breaking offers new challenges. Hopefully it's one that will enhance your present ability and widen your horizons. —*Richard Byrne*

PUBLISHER'S NOTE

Please exercise caution while practicing the techniques described in this book. Often, injuries come through exceeding the recommended schedule, failure to go through the long, toughening phase, human error or carelessness. Make sure that you use only the striking areas called for in each technique. If you have questions regarding the safety of any technique, or if you experience continuing pain after performing a technique, *see your physician without delay.*

CONTENTS

IMPORTANCE OF THE WARM-UP

Just as an automobile won't run efficiently until it's warmed up, your body can't be expected to perform at top form until it's been carefully prepared. To avoid a torn or pulled muscle, you should loosen up with some simple exercises. I've found the following warm-ups beneficial in my training. You may find them helpful when used in conjunction with your own program. Don't rush into training for breaking without first engaging in a proper warm-up session.

NECK ROLL

(1) From the starting position, (2) let you head drop forward so your chin touches your chest, then (3) roll your head to your left, and slowly (4) roll it to the rear. Follow your motion around until your head (5) reaches your right, then return to the starting position. Repeat the entire exercise only this time rotate in the opposite direction. If you rotated your head clockwise, do it counterclockwise the second time. Repeat until your neck and upper back feel loose.

SHOULDER WARM-UP

(1) From the starting position, (2) lift your right arm and rotate it in a circular motion (3) continuing the circle behind you; then (4) drop your arm down behind you and return to the starting position. (5) Place your right arm on your collarbone as your left was before, and from this starting position, (6) lift your arm up and begin rotating it in a circle, (7) continuing the circle behind you until (8) you've returned to the left arm starting position. Repeat each side until both shoulders feel loose and relaxed.

SHOULDER STRETCH

After completing the preceding shoulder warm-up, (1) cross your arms and touch your elbows with one above the other; then (2) keep your arms bent and pull them backward as far as you can. Repeat several times until you're loosened up.

HAND AND WRIST STRETCH

Loosen your hands and wrists by (1) twisting your left hand counterclockwise, then (2) twisting your right hand counterclockwise. (3) Pull back the fingers on your left hand and then (4) pull back the fingers on your right hand. Repeat several times until your hands and wrists are loose and relaxed.

HIP ROTATION

(1) Place your feet shoulder-width apart and put your hands on your waist. (2) Rock your hips forward, then (3) rotate them to the left, continuing the rotation (4) to the rear, and then (5) to your right. Return to your starting position and repeat the exercise, but rotate in the opposite direction. If you rotated counterclockwise initially, rotate clockwise the second time. Repeat several times, switching rotation direction each time.

2

4

5

LEG WARM-UP

(1) With your legs placed widely apart, and your right leg forward, (2) bend your right knee and bring your left heel up off the floor, but keep the ball of your left foot in contact with the floor. (3) Turn your body forward, and keep the side of your left foot flat on the floor. (4) Drop down so your hands almost touch the floor and the toes of your left foot point toward the ceiling. (5) Assume the same opening position only lead with your left leg forward, then (6) bend your left leg and bring your right heel off the floor but keep the ball in contact. (7) Turn your body forward keeping the side of your right foot on the floor, then (8) drop down so your hands come close to the floor and the toes of your right foot point at the ceiling. Repeat until your legs are warmed up and feel limber.

HAMSTRING STRETCH

(1) Assume a well-balanced stance with your legs shoulder-width apart. (2) Reach down and grab onto your left ankle with both hands and (3) try to pull your head down to knee level while keeping your legs *straight*. (4) Switch sides, and reach down and grab onto your right ankle and again try to pull your head to knee level. (5) Then grab both ankles and pull your head along your centerline until it's at knee level. Repeat this several times until you can easily reach knee level.

HAMSTRING AND ADDUCTOR STRETCH

(1) Assume a horse stance and (2) keeping your legs straight, grab onto your left ankle with both hands and pull your head to knee level. (3) Switch sides, then grab onto your right ankle and pull your head down to

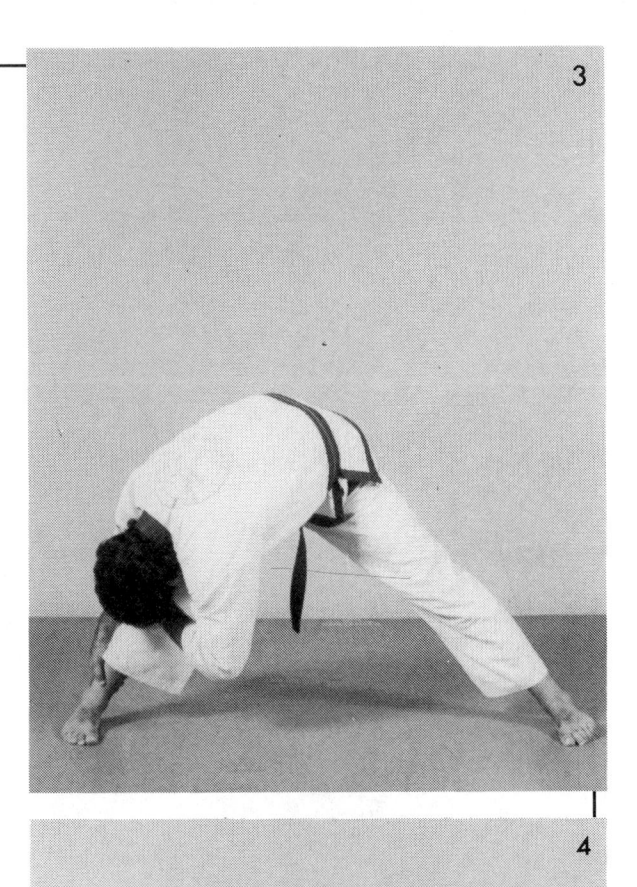

knee level. (4) Then grab both ankles and pull your head down along your centerline until it just touches the floor. Repeat several times. Be sure to do the previous stretch *before* you attempt this one.

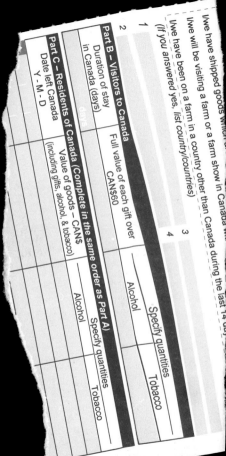

I/we have shipped goods which...... in Canada...

I/we will be visiting a farm or a farm show in Canada...

I/we have been on a farm in a country other than Canada during the last 14 d...

(if you answered yes, list country/countries)

1	3
2	4

Part B – Visitors to Canada

Duration of stay in Canada (days)	Full value of each gift over CAN$60	Alcohol	Specify quantities	Tobacco

Part C – Residents of Canada (Complete in the same order as Part A)

Date left Canada Y - M - D	Value of goods – CAN$ (including gifts, alcohol, & tobacco)	Alcohol	Specify quantities	Tobacco

Âge minimum	Province ou territoire	Alcool et tabac
		Alcool et de tabac
18 ans	Alberta, Manitoba, Québec	1,5 l de vin ou 1,14 l de spiritueux ou 24 bouteilles ou cannettes (355 ml ou 12 oz) de bière ou d'ale (8,5 l)
19 ans	Autres	
18 ans	Alberta, Manitoba, Québec, Saskatchewan, Territoire du Yukon, Territoires du Nord-Ouest, Nunavut	200 cigarettes, 200 bâtonnets de tabac, 50 cigares ou 50 cigarillos et 200 g de tabac fabriqué
19 ans	Autres	

Lors de votre séjour à l'étranger, vous avez peut-être été exposé à des maladies infectieuses rares au Canada. Même si le risque de contracter ces maladies est faible, certaines maladies, comme la malaria, peuvent être mortelles. Si vous faites de la fièvre ou avez les symptômes de la grippe au... ...un pays tropical, Santé C...

TRAINING
AND CONDITIONING

In this chapter, you'll discover some of the training and conditioning methods which have proved useful in preparing for a variety of breaks. These methods are only to be used *in addition* to regular and steady work under a qualified instructor. Good basic knowledge of these techniques is essential if you're to avoid injury, break successfully, and use the skill of board breaking as a complement to training in the martial arts. You should not attempt or move on to a new exercise until you've attained some skill in the previous one, and you should not attempt any breaking until you've trained thoroughly. Tailor these methods to fit your individual needs or goals.

A note of caution: when using the practice board, do not use full force on your initial practice sessions. After you get used to the practice board, increase your speed and power and the number of repetitions of each technique. You will have to allow time for the tissues of your hands and feet to become accustomed to the impacts. In fact, that's the point of using the board. Start gradually and build up as your hands and feet toughen.

When beginning training, strike 20 times with each hand starting with easy strikes and building up until the last five strikes are done at full power, or as hard as you can strike without excessive pain. This should be done three times per week. Caution should be used to prevent injury. Be sure you are striking with the right area of the hand or foot. If excessive pain occurs, then delay training for one week before beginning again. Causing damage to yourself will result in a longer lay-off from training or even make you gunshy; afraid to throw a particular technique due to fear of injury. This will handicap you as a martial artist, for you will be unable to react quickly with a clear mind in a sparring or self-defense situation.

You will feel some degree of discomfort if you are not used to breaking. This is to be expected. Pain ceases to be pain when there is a goal to achieve. You will be surprised at the degree of power with which you can strike the punching board in a relatively short time of training. Psychologically, you will be training your mind to block out pain and as a result, build up your resistance to it.

PROPER STRIKING AREAS

To avoid injury and complete your break, you must strike with the proper part of the body. The techniques illustrated are quite basic, and shouldn't be new or unknown to any martial arts practitioner. Be sure to practice often to insure that you're consistently using that precise (and correct) part of your body and *only* that part when striking your target. Training in breaking is intended to enhance your ability to strike with correct technique. Correctness will insure your safety so that you may continue your training without the set-

FRONT PUNCH: Strike with the first two knuckles.

BACK FIST: Strike with the back of the first two knuckles.

HAMMERFIST: Strike with the lower portion of the hand.

CHOP: Strike with lower portion of the hand.

back of injury. Correctness will also improve your breaking ability. And then, as you become more proficient in breaking, you will be able to increase your striking speed and power, and progress to more difficult breaks. More difficult breaks will further challenge and improve the correctness of your technique. In this way, training in breaking will make you a better martial artist, but it is essential to remember that correctness is the key to it all.

REVERSE CHOP: Strike where thumb and index finger meet.

FINGER JAB: Strike with the tips of the first three fingers.

PALM STRIKE: Use the lower portion of the palm of the hand.

CHICKEN WRIST: Strike where the top of the wrist begins.

THUMB STRIKE: Strike with the tip of the thumb.

HEAD STRIKE: Strike with the curvature of the forehead.

FRONT KICK: Strike with the ball of the foot.

ROUND KICK: Strike with the ball of the foot.

SIDE KICK: Strike with the rear edge of the foot.

BACK KICK: Strike with the bottom of the heel.

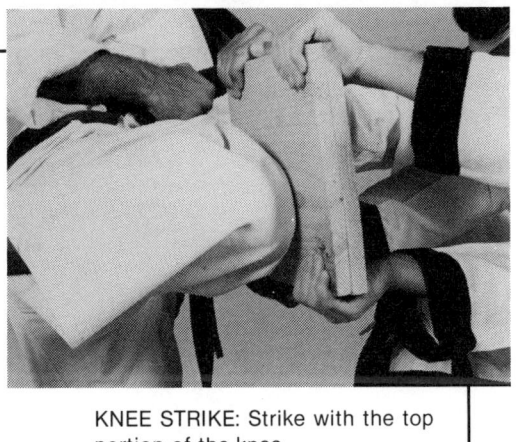

ELBOW STRIKE: Strike with the flat portion of the arm below the elbow.

KNEE STRIKE: Strike with the top portion of the knee.

REVERSE ROUND KICK: Strike with the ball of the foot.

INSTEP ROUND KICK: Strike with the instep of the foot.

CRESCENT KICK: Strike with the back of your heel.

HOOK KICK: Strike with the back of your heel.

31

PRACTICE TARGETS

Cardboard and a punching board designed for the purpose may be used to practice techniques. A small target will help you develop kicking percision. Several types of strikes are illustrated.

FRONT PUNCH: Use your first two knuckles when striking the cardboard.

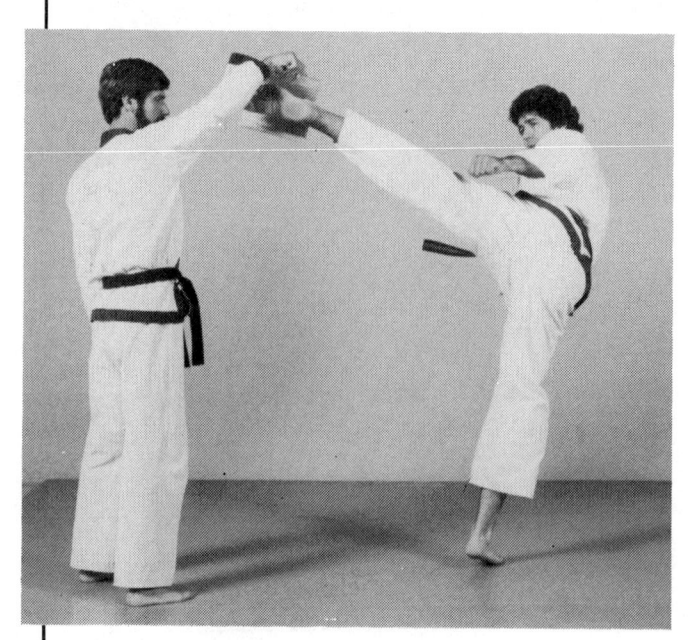

ROUND KICK: Hit with the ball of your foot.

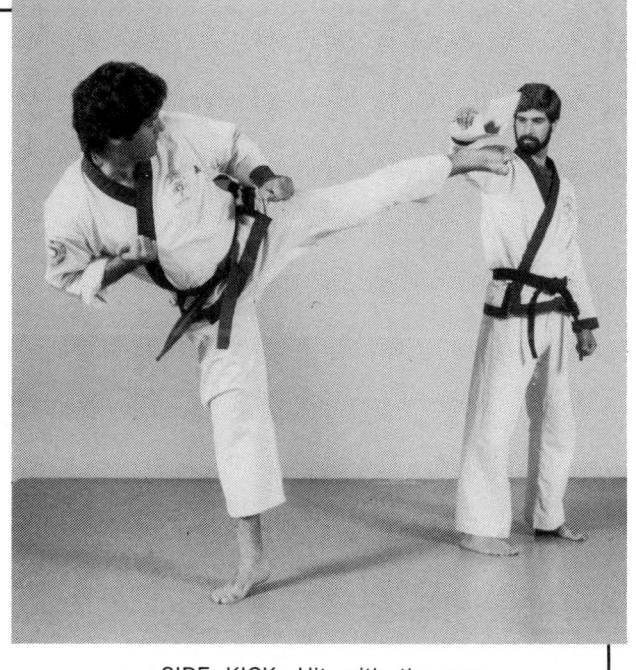

SIDE KICK: Hit with the rear edge of the foot.

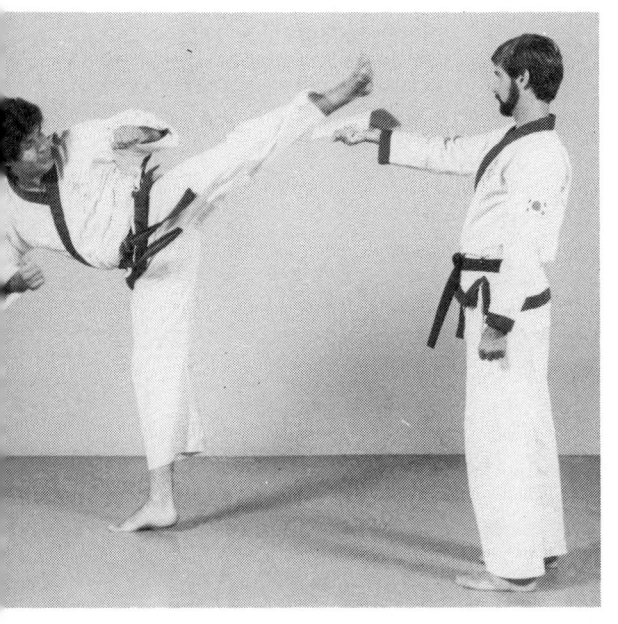

HOOK KICK: Strike with the back of your heel.

FORWARD PUNCH

When using a practice punching board, (1) you first assume the ready stance, then (2) extend your striking arm out slowly so it touches the board with your elbow still slightly bent, thus measuring your punch. (3) Pull your arm back into the loaded position and

then (4) deliver your punch to the board. Practicing on the board will develop focus, strength and toughen your hands. Practice with both hands, alternating after several blows, and increase speed and power as you become used to the feel of the board.

CHOP

Be sure that you strike with the rear portion of the hand, avoiding the fingers. Angling the fingers slightly away from the board will help to insure this. (1) Extend your arm and hold your hand's outside edge pressed against the board with your elbow slightly bent. (2). Pull your arm back and prepare to execute the blow. (3) Snap your arm out and hit the board. When striking, try to shift your weight into the strike as if you want to go through the punching board; this will improve your technique for breaking.

BACKFIST

(1) Hold the back of your knuckles against the board with your elbow slightly bent. (2) Pull your arm back and up alongside your neck and prepare to execute the blow. (3) Snap your backfist out and into the board. Be sure that you are striking with only the backs of the first two knuckles.

CHICKEN WRIST

(1) Push your wrist into the board in the correct form while keeping your elbow slightly bent. (2) Pull your arm back and prepare to execute the blow. (3) Snap the blow out and into the board. Bend the hand toward you until you are at a 90-degree angle to your arm. This will better expose the striking area.

REVERSE CHOP

(1) Extend your arm out and hold your hand against the board with the index finger edge pressed against the board. (2) Pull the arm back and prepare to execute the blow, then (3) whip your arm forward into the board. Be sure to roll your hand slightly so your thumb is under and out of the way. No part of your thumb or joints of the thumb should touch. The thumb can be easily injured, so be cautious. To prevent hyperextension at the elbow upon impact with the board, it is recommended you strike with your elbow slightly bent. Turn your hips back away from the board with your arm when loading and turn them back toward the board when you deliver the blow.

FRONT KICK

(1) From the ready stance, (2) lift your knee up and (3) snap your kick out and into the board. Be sure your toes are pulled back as far as possible to insure striking with the ball of the foot and avoiding injury.

ROUND KICK

(1) From the ready stance, (2) lift your knee up and (3) execute a round kick into the board. Be sure your toes are pulled back as far as possible to insure striking with the ball of the foot and avoiding injury. Make sure you pivot the supporting foot at least half way, to allow the hip to get behind the kick. This is imperative in developing a strong round kick.

INSTEP ROUND KICK

Be sure to point your foot and roll your toes under as far as possible. This will expose the instep area better and prevent you from hitting the tops of the toes. (1) From the ready stance, (2) lift your knee up and (3) strike the board crisply with your instep. Allow your supporting foot to pivot at least halfway to insure your hips are behind the kick which will help your power.

SIDE KICK

Be sure your distance is correct, hitting too closely can cause you to strike with the front or middle of the side of the foot instead of the rear edge. If any part but the rear edge makes contact, an injury could occur. (1) From the ready stance, (2) lift your knee up and (3) snap your kick out and into the board. Make sure your foot pivots entirely so that your heel of the supporting foot is pointing in the direction of the target.

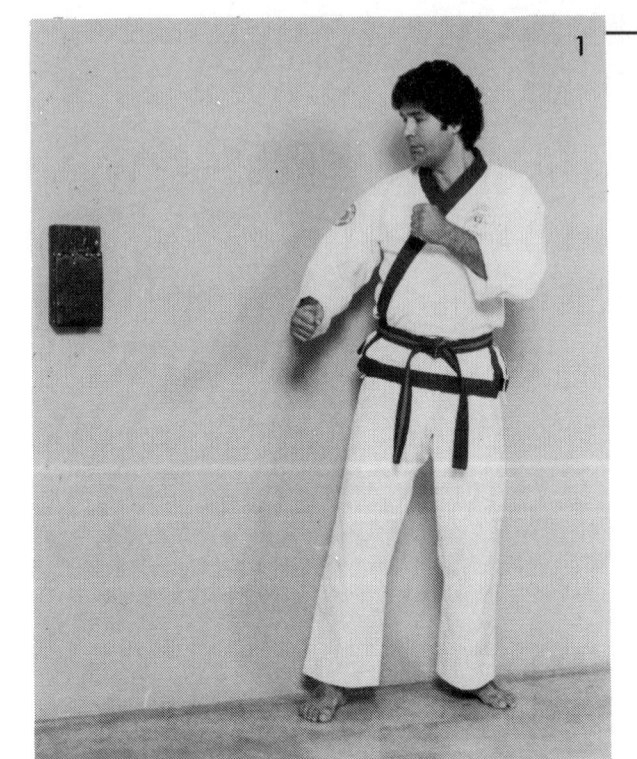

HOOK KICK

(1) From the ready position, (2) raise your knee up and (3) snap your kick around until (4) it impacts on the board. Be sure to strike with the back edge of the heel, not the bottom. Also when impact occurs, the

knee should be bent. Never strike with the leg locked out as hyperextention may occur. Pivot the hip toward the target. Don't just kick with your leg, use your hips.

KNUCKLE PUSH-UP

To develop strong fingers, chest and arms, execute 20 or more knuckle push-ups three times a week during each training session. (1) From the starting position, (2) lower yourself down slowly on your knuckles until your chin touches the floor. Keep your legs locked straight and your body flat.

FINGERTIP PUSH-UP

An even more difficult exercise, these push-ups can toughen your fingers. (1) From the starting postition, (2) lower yourself down on your fingertips until your body just touches the floor, keeping your legs locked straight and your body flat. Repeat 20 or more times.

ADVANCED FINGERTIP

(1) From the starting position, using only your thumb and first two fingers on each hand as support, (2) lower yourself slowly to the floor, keeping your legs locked straight and your body flat. Repeat 20 or more times.

FINGER THURST

This exercise is used to toughen the skin of your hands and strengthen the muscles of your hands and wrists. Obtain a deep container that you can fill with chick-peas or dried beans. Place the container full of peas on a sturdy support about groin height, and (1) stand over the container. Prepare to thrust your open hand into the peas.

(2) Drive your hand downward into the peas and (3) continue your thrust until you're stopped by the resistance of the peas. Your goal is to hit bottom when you strike. If you do, get a deeper container and add more peas. Stop thrusting when your fingertips strike the bottom of the container. Repeat this exercise 20 times with each hand, three times a week.

BASIC BREAKING;
SET-UPS AND MATERIALS

This chapter covers basic hand and foot techniques. Special attention should be given your set-up and the positioning of your assistants and yourself. The distance between you and your target will change according to the height of the break and the length of your arms and legs.

A proper set-up is important in breaking training. A set-up can be either an assistant holding the board for you, or the use of cement blocks as supports. The quality of a breaking performance really depends on the set-up. A poor one can be costly, not only for the person executing the break, but for those helping who have fingers pinched, jabbed full of splinters, or broken. The set-ups in this section are basically standard, but can be altered to accommodate different techniques, as long as the alterations still maintain the same degree of safety.

The materials you choose to break are also critical. The boards used here are one-inch-thick by 12-inches wide by ten-inches long pine. Both a wide board and a narrow board may be used. A narrow board is usually an easier break assuming identical thickness. Pine varies in hardness, but generally, the lighter the board the easier it is to break. Choose wood without knots, as they make a board heavier and also can cause it to break unpredictably. Be careful in selecting breaking materials, and your success will be improved. Keep in mind that, although the execution of the technique is important, so are the materials and the set-up.

STACKED BOARDS
(On cement block)

The board ends must rest at least one-quarter inch on the tops of the blocks.

BOARDS WITH SPACERS

When using spacers be sure they're stacked evenly and the same distance from the center of the boards. Uneven stacking or spacer height will result in an unpredictable break.

HOLDING THE BOARD
(For suspended breaks with hand on top)

Position your assistant with the board extended at arm's length away from his body, gripping the board from the top. The thumb must be held adjacent to the other fingers away from the point of impact.

HOLDING THE BOARD
(For suspended breaks with hands at the bottom)

Position your assistant so that the board is aligned with the middle of his body, both hands gripping the board at the bottom on opposite sides. His arms must be fully extended away from his body, his thumbs held down away from the point of impact.

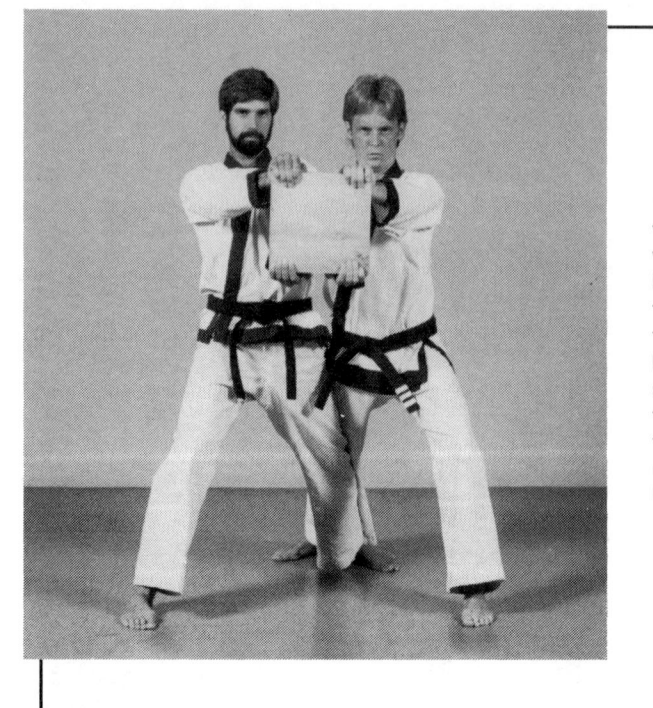

HOLDING THE BOARD
(Vertical hands)

Position your assistants with their feet spaced widely apart, gripping the board from the top and bottom. They should be able to lean back to absorb the break. Their rearward legs should create a locking tripod effect. The grain of the wood on this break runs from left to right. The board will break horizontally.

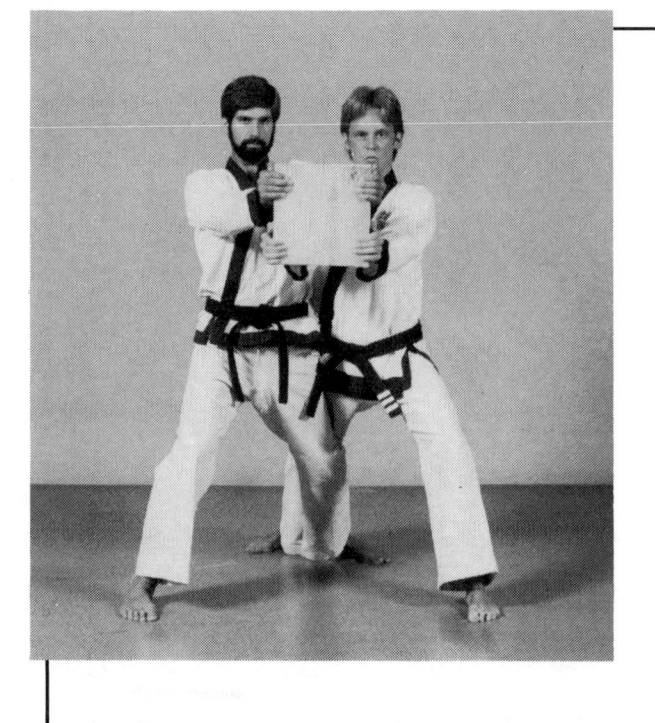

HOLDING THE BOARD
(Horizontal hands)

Position your assistants with their feet spaced as with the previous break. They should grip the board firmly by the sides, with the hands of one assistant at the top; the other at the bottom. The grain of wood runs from top to bottom. The top and bottom grip is necessary to prevent the assistants from getting their fingers hurt. They must be able to lean back to cushion the shock of the break. The board will break vertically.

HOLDING THE BOARDS
FOR HEAVY BREAKING
(Vertical hands)

Position your assistants in a posture similar to the previous break, but farther apart so a second pair of assistants may then stand between the original pair. These assistants will take a solid grip on the wrists of the original pair. The additional assistants stand with their feet matched up and directly next to the original two. They must be able to lean back to absorb the shock. The woodgrain runs from left to right. The boards will break horizontally.

HOLDING THE BOARDS
FOR HEAVY BREAKING
(Horizontal hands)

Position your assistants as in the previous break, only be sure that they grip the wood from either end. The second pair will act as wrist and arm braces for the original pair. The placement of their feet is identical to that of the previous break. They must be able to lean back to absorb the force. The woodgrain runs from top to bottom. The boards will break vertically.

FRONT PUNCH

(1) Place your assistants next to each other at a distance of about three feet from you (as you should do for all the following techniques). The grain of the wood runs from left to right. From your ready stance (2) pull your arm back and prepare to deliver the punch. (3) Snap your arm out and (4) follow through with your blow to insure that you break the boards.

Practical Application: A front punch to the solar plexus.

PRACTICAL APPLICATION

BACKFIST

(1) The grain of the wood runs from left to right. From your ready stance, (2) pull your arm back and prepare to deliver the blow. (3) Snap your backfist out and (4) follow through with it to insure that you break the board. Shift your weight back slightly as you load your arm then shift it toward your target to insure good follow-through. Be sure to strike only with the back of the first two knuckles.

Practical Application: A backfist to the side of the head.

PRACTICAL APPLICATION

57

HAMMERFIST

(1) In loading the hand, bring it as far behind you as possible with the palm of your hand turned away from you. This will allow for more velocity to be attained, and snapping the wrist to strike with the hammerfist will increase your power. The grain of wood runs up and down, not horizontally. From your ready stance, (2) pull striking arm up and back and then (3) bring it down on the boards. (4) Follow through to insure the break. Allow your shoulder to lean into the technique for a good follow-through.

Practical Application: Double hammerfist to the rib cage.

PRACTICAL APPLICATION

PALM STRIKE

(1) The grain of wood runs from left to right. From your ready stance, (2) bring your arm back and (3) snap your palm strike out and (4) follow through to insure the break. Be sure to pull your wrist and fingers back as far as they can go. When striking, keep the elbow bent as this will allow you to strike with the palm area more efficiently. Turning the hips toward the boards will help your follow-through.

Practical Application: A palm strike to the chin or nose.

PRACTICAL APPLICATION

ELBOW STRIKE

When loading the elbow, you should grab your hand of the arm with which you intend to strike. This helps to keep the technique accurate. (1) The grain of the wood runs from left to right. From your ready stance, (2) cock your elbow back and (3) drive it forward and (4) through the boards. Be sure to follow through. Your arm should always be bent back tightly against your bicep to insure the arm is solid. The palm of the hand should be facing downward which will help you to strike the elbow in a proper position.

Practical Application: An elbow strike to the face.

3

4

PRACTICAL APPLICATION

CHOP

When loading the hand, be sure the palm is facing away from you and bring the hand back as far as you can. (1) The grain of the wood runs vertically. Hold your striking arm parallel to your chest. From the ready stance, (2) pull your arm back and then (3) snap it down onto and (4) through the boards, using the edge of your hand as the striking surface. Follow though. In delivering the chop, allow your hips and shoulder to turn towards the target as this will allow for proper follow-through. *Practical Application:* A chop to the base of the ear.

PRACTICAL APPLICATION

REVERSE CHOP

Swinging the hips back as you load your hand will give you better power with the use of the body, and upon contact with the boards, will insure proper follow-through. Be sure your arm is slightly bent at the elbow to avoid hyperextension. (1) The grain of the wood runs horizontally. From your ready stance, (2) pull your striking hand back and then (3) drive it forward and (4) through the boards. Follow through. Only the index finger edge of your hand contacts the board.

Practical Application: A reverse chop to the ribs, solar plexus, or abdomen.

PRACTICAL APPLICATION

CHICKEN WRIST

(1) The grain of the wood runs horizontally. From your ready stance (2) pull back the striking arm and (3) snap your arm forward into and (4) through the boards. Follow through, and keep your wrist bent through the entire strike. Bend the arm toward you until you are at a 90-degree angle to your arm. This will better expose the striking area.

Practical Application: Chicken wrist strike to the ribs, solar plexus, or abdomen.

PRACTICAL APPLICATION

FINGER JAB

In this technique, the middle finger should bend slightly to match the length of the index finger and ring finger. The striking point should be with the tips of these three fingers. Although the middle finger is bent, the others are locked-out straight. This will give you more resistance when striking the boards. Use of the hips is important. As you load, rear back, turning your hips away from the target. As you strike, twist them sharply toward the boards. (1) The grain of the wood runs horizontally. From your ready stance, lock your fingers in the extended position, (2) pull your striking hand back, and (3) thrust your hand forward, (4) penetrating and breaking the wood. Your fingers must stay rigid and straight through the complete thrust. Follow through.

Practical Application: Finger jab to the throat.

PRACTICAL APPLICATION

FRONT KICK

Be sure to bend the toes back as far as possible to make sure the ball of the foot is what strikes the wood. When loading, bend the knee up high with the foot under the knee and be sure to snap the kick quickly. Shifting the hip forward at the moment of impact will aid in increasing your ability to follow through. (1) The grain of the wood runs vertically. From your ready stance, (2) raise your knee and prepare for your kick. (3) Snap your kick out and (4) penetrate and break the boards. Follow through with your kick to insure that you break the wood.

Practical Application: Front kick to the solar plexus.

PRACTICAL APPLICATION

ROUND KICK
(Using ball of foot)

When loading, make sure the knee tucks up in line with the boards. Pull the toes back to insure contact with the ball of the foot. Keeping the arms close to your body will help your balance and control. Pivot your supporting foot about three-quarters of a turn and make sure you use your hips to drive the kick for a good follow-through. (1) The grain of the wood runs horizontally. From your ready position, (2) lift your leg out and pull your knee up. (3) Snap your leg out and around and (4) penetrate and break the boards. Follow through with the circular motion of the kick. *Practical Application:* Round kick to the solar plexus.

PRACTICAL APPLICATION

SIDE KICK

Be sure to tuck up the knee at least as high as the target. Your supporting foot should pivot completely so the heel is lined up with the boards. (1) The grain of the wood runs horizontally. From your ready position, (2) pull your knee up and get ready to (3) snap your kick out into and (4) through the boards. Follow through with your kick to assure penetration. Always keep your eyes on your target. Keeping your arms close to the body helps in balance and control. Distancing is also extremely important. A small mistake in distancing either too far or too close will result in failure to complete your break.

Practical Application: Side kick to the face, neck or solar plexus.

PRACTICAL APPLICATION

KNEE KICK

(1) The grain of wood runs horizontally. From your ready position, (2) tuck up the knee so it is level with the target. Pivot the supporting foot halfway and thrust the hips behind the knee. Be sure to strike with the top of the knee, not the knee cap or joint. Keeping the leg bent as much as possible will help keep the striking area tight. (3) Pull your leg up and back and then bring it forward so the knee (4) strikes and penetrates the boards. Follow through, and be sure you strike with the hard part of your knee, *not* the kneecap or joint area.

Practical Application: Knee kick to the abdomen.

PRACTICAL APPLICATION

OUTSIDE CRESCENT KICK

(1) The grain of the wood runs vertically. From your ready position, (2) tuck your knee up to chest height. (3) Snap your lower leg up, getting your foot as high over the boards as possible. (4) Drive your heel downward through the boards, shifting your weight slightly forward to help penetrate the wood. Make sure you strike with the back of the heel, not the bottom. Keep the knee slightly bent on impact to prevent hyperextension.

Practical Application: Crescent kick to the side of the head.

3

4

PRACTICAL APPLICATION

INSIDE CRESCENT KICK

(1) The grain of the wood runs vertically. From your ready position, (2) bring your knee up high for the load. (3) Snap your leg out and around toward your side as high as possible over the boards, and (4) drive your foot downward through the boards. Follow through with your kick. Be sure to strike with the back of the heel and keep the knee slightly bent on impact to prevent hyperextension.

Practical Application: Inside crescent kick to the head or neck.

3

4

PRACTICAL APPLICATION

83

BACK KICK

(1) The grain of the wood runs horizontally. From your ready position, (2) pivot around so your back faces the target, but be sure to keep your eyes locked on the boards. Bring up your knee and (3) snap your striking leg out as you straighten your body, and (4) follow through with the kick to break the wood. As you kick, twist your upper body sharply away from your target. When you snap your body in the direction opposite the kick, you direct more thrust into the target. It's similar to the power generated by unwinding a spring.

Practical Application: Back kick to the face, neck, or solar plexus.

PRACTICAL APPLICATION

INSIDE ROUND KICK

Tuck up the knee level with the boards. Pivot your supporting foot to three-quarters of a turn snapping your hips with the kick. Be sure to point your foot and pull your toes down to expose the instep for better striking area. Do not strike with the tops of the toes. (1) The wood grain runs horizontally. From your ready position, (2) lift your knee and prepare for your kick. (3) Snap your kick out so that your instep (4) strikes and breaks the boards. Always follow through.

Practical Application: Instep round kick to the face.

PRACTICAL APPLICATION

INVERTED ROUND KICK

Tuck up the knee level with the boards. At the same time, thrust it to the front away from the boards. Then reverse direction toward the target. Make sure your toes are tucked up out of the way and you strike with the ball of the foot. (1) The wood grain runs horizontally. From your ready position, (2) lift your knee and bring your foot around so (3) it snaps out and then (4) strikes the board with the ball of your foot. Follow through.

Practical Applicaton: Inverted round kick to the face.

PRACTICAL APPLICATION

HOOK KICK

Be sure to strike with the back of the heel, not the bottom and use your thigh and hip to drive the kick through the wood. Upon impact, the knee should be bent slightly to prevent hyperextension of the knee. (1) The wood grain runs horizontally. From your ready position, (2) take a step forward with your left foot, (3) bring your right foot up to meet your left. (4) Raise your knee and (5) snap your kick out so that your heel (6) will strike and break the wood. You must whip your kick around with a crisp snapping motion and always follow through to insure a break.
Practical Application: Hook kick to the face.

3

PRACTICAL APPLICATION

6

FLYING KICKS

You must remember that the ability to perform good standing kicks doesn't mean you'll execute good jump kicks. Jump kicks are a separate skill, and must be learned as all other skills are. If you're having trouble with jump kicks, or any of the breaks in this chapter, consult your instructor. You may need additional training to hone your jumping skills.

Don't get discouraged. With persistence, you should be able to perform any of the following techniques. And remember, as with all breaking techniques, start off with one board and add more only when you can break a single piece with ease and predictability.

JUMP FRONT KICK

(1) When your assistants are in position, get into a ready stance and (2) take one step forward with your right leg, then (3) snap your left leg up into position and (4) thrust yourself off the ground with your right leg. (5) Snap your right leg out, into and (6) through the boards. Execute the moves briskly and smoothly. Follow through with your kick to insure a break.

JUMP ROUND KICK

(1) From your ready position, (2) take one step forward with your left foot then (3) snap your right knee up and thrust off the ground with your left leg.

96

(4) Pivot at the waist, bring your left leg around, then (5) snap your leg out to strike and (6) break the boards.

FLYING SIDE KICK

(1) From your ready position, (2) take a step forward with your left foot, and then (3) another step forward with your right. (4) Snap your left leg in and up as you push off the ground with the right leg. (5) Tuck both legs up and then (6) snap your left leg out, so it strikes and (7) breaks the boards. This can be executed with the right leg by simply altering your angle to the target and starting the technique with your right leg.

JUMP BACK KICK

(1) From your ready position, (2) jump up and pivot so your back is to your target. Keep your head turned so you can face the target, then (3) tuck your legs up

while turning and (4) snap your striking leg out to strike and (5) break the boards. Execute all the moves in one fluid motion.

JUMP TURNING BACK KICK

(1) From your ready position, (2) step forward with your left foot then (3) step forward with your right, and as soon as it touches the floor, push off and (4) jump. As you jump, pivot around so your back is to-

ward your target during the
jump, but keep your eyes
on the boards. (5) Snap
your striking leg out behind
you, (6) breaking the wood.
Execute the moves fluidly
and crisply.

SPECIAL BREAKING

With these more difficult techniques, you'll be using suspended boards as well as special materials such as rocks and glass. A word of caution: do not attempt these techniques without extensive training and proper supervision, or you may seriously injure yourself. In most cases, pine boards break predictably. Rocks and glass break jaggedly or shatter, creating razor-sharp edges. It's difficult to predict just how they'll break. Use caution and study your breaking techniques thoroughly *before* attempting these breaks.

SUSPENDED SPEED BREAK

(1) Hold your target at a comfortable distance away from your chest. Hold the board at the top with a firm grip, and from your ready stance, (2) pull your striking arm back and (3) snap your punch forward at high velocity so you strike and (4) break the board. Follow through to insure a break.

Punching velocity is important for this and all suspended breaks. As with all breaks, start out with one board and when you've perfected your technique, add more, keeping in mind there's a limit as to how many a single hand can hold.

REVERSE CHOP
(Boards suspended)

(1) When your assistant is in place, rest the edge of your striking hand on the target to measure it for the breaking blow. Prepare for your strike and then (2) pull your hand back and (3) snap it out across the tar-

get, striking and (4) breaking it. Velocity is important here, also, as is good form with the position of your hand. Only the index finger .edge should strike the board for a clean break.

THUMB THRUST

(1) Once your assistants are in place, get into your ready stance and (2) pull your striking hand back and extend the thumb on that hand. Hold it locked in the extended position, then (3) snap that hand forward so that the extended thumb (4) breaks the boards. Be sure to keep your thumb rigid and locked to insure a good break. Also follow through for maximum power.

Practical Application: Once it's perfected, you can thumb thrust to the throat or eye.

PRACTICAL APPLICATION

111

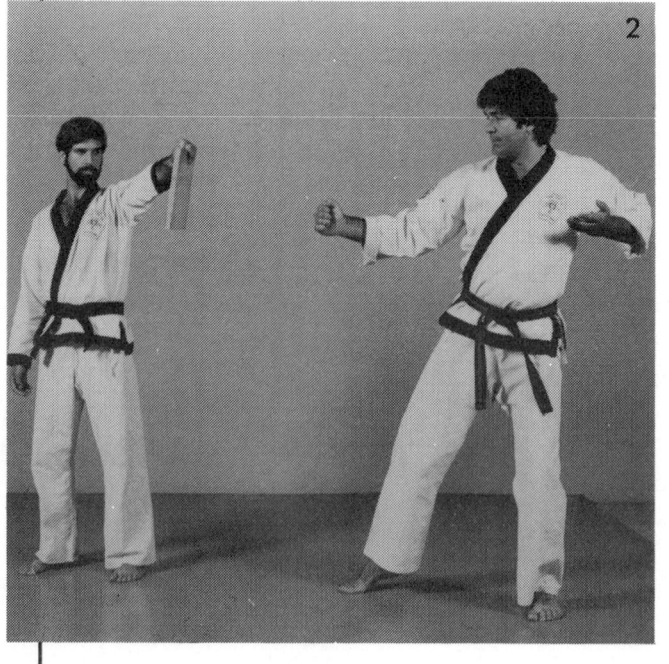

FINGER JAB
(Board suspended)

(1) Once your assistant is in place, get into your ready stance and (2) pull your striking arm back with the fingers locked straight. (3) Snap that arm forward

and drive the extended hand into and (4) through the board. Speed is essential for a clean break, as are solidly locked fingers.

FOREHEAD STRIKE

(1) Once your assistants are in position, (2) lean back and (3) drive your upper body downward and forward so the apex of your forehead strikes and (4) breaks the board. Be sure to hit *only* on the topmost part of the forehead, and follow through. *Practical Application:* Forehead strike to the temple.

PRACTICAL APPLICATION

REVERSE HOOK KICK
(Boards suspended)

(1) Once your assistant is in place, (2) turn your back to him and then (3) lift your striking leg up and (4) snap your kick out and around to (5) break your target. Speed in the hooking motion is essential, as is following through.

Practical Application: Reverse hook kick to the face or neck.

PRACTICAL APPLICATION

JUMP REVERSE
HOOK KICK
(Boards suspended)

(1) Once your assistant is in place, (2) jump and pivot so your back faces him, and then (3) pull your left leg up and (4) snap it out

and around so it's fully extended before you (5) strike and (6) break the boards. Your momentum will complete the break.

BOTTLE PALM STRIKE

(1) Hold a bottle firmly in one hand and get into a ready stance. (2) Raise your striking arm, and with the flat of your palm as the striking surface, (3) bring your hand down hard and fast on the mouth of the

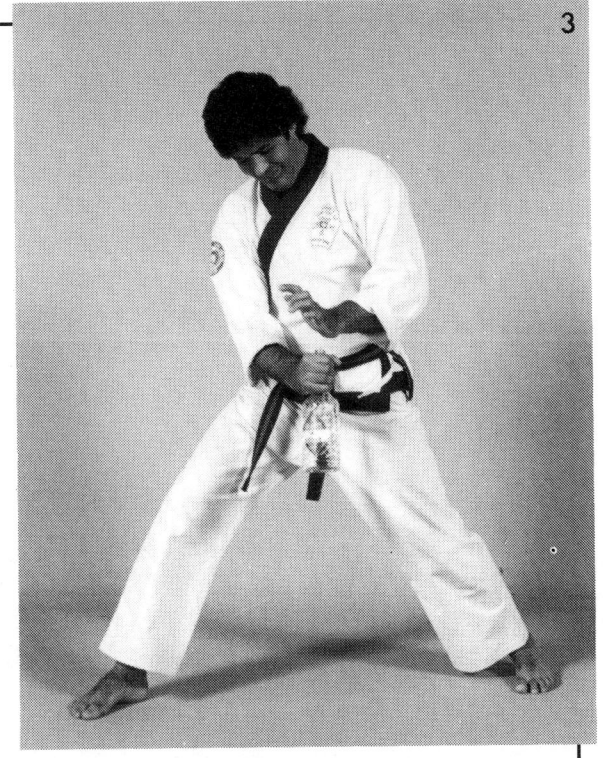

bottle to (4) shatter the lower part of it. Velocity is extremely important here, and this will not work unless your final strike is very quick and firm. Use caution when breaking glass.

ROCK BREAKING CHOP

(1) Select a rock that is as flat as possible and oblong. The denser and heavier a rock is, the harder it is to break. The rock used for this demonstration weighed about eight pounds. (2) Hold the rock in your right hand balanced by your thumb and little finger so the rock is elevated about an inch from the cement block base. (3) Measure your strike, be sure to hit in the center, and do not let the rock move when striking. (4) Bring your striking arm back and (5) drive it down onto the rock so only your hand's edge hits the target. (6) The rock will split along a natural breaking line, so beware of sharp chips.

2

3

5

6

ROCK BREAKING PUNCH

(1) After selecting a flat rock (the one shown in the photo weighed about ten pounds), place a cloth on the rock to protect your skin from the jagged edges that will be created by the

break. (2) Draw your striking arm back and (3) drive your fist down onto your target and (4) follow through to complete your break. Watch out for flying chips.

TEN BOARD CHOP

After you've become really proficient at breaking, you may want to attempt to break larger thicknesses of boards. Your success with single and smaller numbers of boards will, of course, determine how many you should attempt. In this case, a stack of ten boards is set on the cinderblock base with the edge about a quarter-inch onto the blocks. The boards are one-

inch-thick pine. (1) Assume your ready position, and prepare for your break. (2) Raise your striking arm and then (3) drive the edge of your hand downward onto the boards and (4) follow through until the top board breaks. Remember, when no spacers are used, the top board will be the *last* to break. On breaks of this type, you must have perfect concentration and technique.

I have been on many demonstrations where Richard Byrne and his demo team have performed. Richard Byrne has proven to me that one does not have to be a master or grandmaster to do breaking safely. At his recitals, many of his lower- and upper-rank students can perform the breaking techniques safely.

I am recommending this book to all martial artists to be included in their martial arts library, especially those interested in learning breaking techniques the safe way. Breaking is safe under the direction of Richard Byrne.

Professor Wally Jay,
International Head of Jujitsu Dai Nippon Butoku-Kai

I have a tremendous amount of respect for Richard Byrne as a martial artist and as a friend. In my opinion, his ability and versatility in the area of breaking is incredible.

I've worked with Richard many times and have seen first hand the confidence he inspires in the people around him.

Here it is, everything you've always wanted to know about breaking but were afraid to ask! Ask my friend Richard Byrne—he is the expert.

Bill "Superfoot" Wallace,
Former World Middleweight Full-contact Karate Champion

Byrne's reputation as a leading authority on board breaking has made him one of the most respected men in the martial arts world today. When it comes to breaking, I have personally witnessed the phenomenon and it is almost beyond belief. I think the reader can surprisingly gain a great deal about breaking with the advice and influence of this book.

Joe Lewis,
Former Heavyweight Point Karate Champion